ARTIST'S
WORK
BOOK

The Practical Guide to

DRAWING
MANGA

PETER GRAY

ARCTURUS

ARCTURUS

This edition published in 2009 by Arcturus Publishing Limited
26/27 Bickels Yard, 151–153 Bermondsey Street,
London SE1 3HA

Series Editor: Ella Fern

ISBN: 978-1-84837-276-4
AD001171EN

Printed in China

ARTIST'S
WORK
BOOK

The Practical Guide to

DRAWING
MANGA

CONTENTS

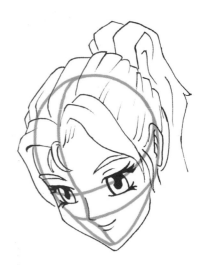

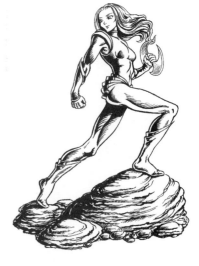

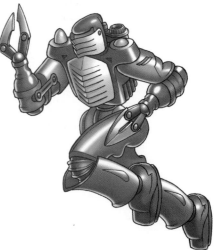

INTRODUCTION

From its origins in Japanese comics, manga has become one of the most visible drawing styles across the world, in animation, computer games, advertising and design. The style is characterized by dynamic and glamorous character design, fast-moving action and polished draftsmanship.

This book aims to concentrate on characters – how to draw faces and figures with accuracy and personality, how to achieve that particular manga look and how to create new characters of your own.

Designed as a course, each new subject follows naturally from the previous one. Step-by-step demonstrations will teach you the most basic principles and then gradually lead you to greater sophistication. With some application, even the complete beginner should soon be able to produce satisfying results.

Try to resist the temptation to simply copy pictures from the book. Work through from the start and do all the exercises so that you can build up to creating your own dramatic drawings with confidence.

Don't be put off by the slick look of artwork by professional manga artists; it isn't too hard to emulate once you know some tricks of the trade. We will investigate various materials and techniques in easy-to-follow stages.

Create new characters out of diverse inspirations.

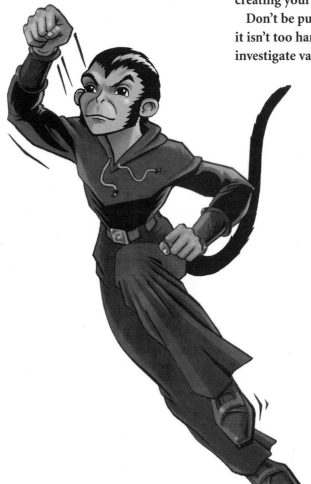

Study the construction of manga body types.

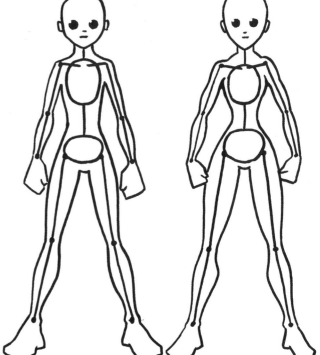

6

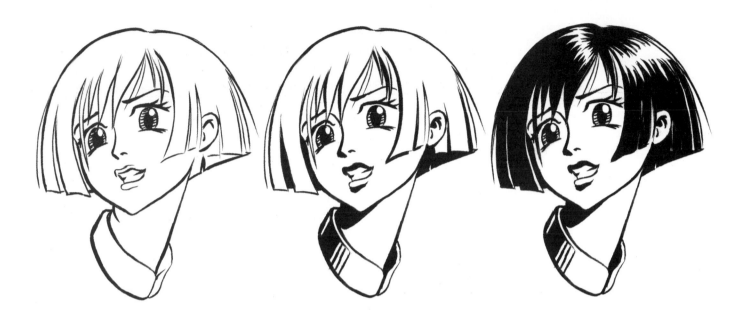

The 200 or so illustrations in this book represent only a fraction of the techniques and stylistic approaches open to you as you continue to develop your mastery of manga.

Above all, remember that drawing is supposed to be enjoyable. Even if it seems like hard work at times, stick with it and you will soon enjoy the rewards of your efforts.

Build up to professional-quality artwork in easy stages.

Capture distinctive manga features with authenticity.

Draw figures with dynamic posture and proportions.

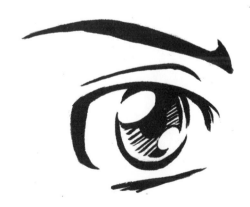

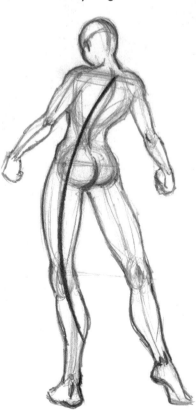

BASIC MATERIALS AND EQUIPMENT

One of the great things about any style of drawing is that you need very little equipment to get started. Beginners often make the mistake of buying all kinds of expensive materials, but these do little to improve your skills and only confuse the issue of learning to draw. To start with, you'll need only pencils and a pencil sharpener, paper, and an eraser.

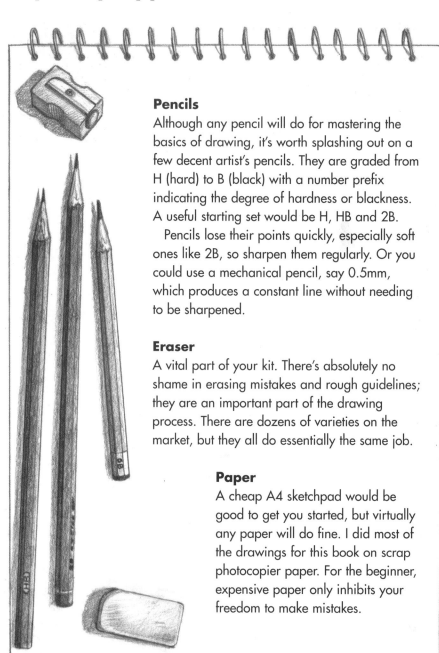

Pencils

Although any pencil will do for mastering the basics of drawing, it's worth splashing out on a few decent artist's pencils. They are graded from H (hard) to B (black) with a number prefix indicating the degree of hardness or blackness. A useful starting set would be H, HB and 2B.

Pencils lose their points quickly, especially soft ones like 2B, so sharpen them regularly. Or you could use a mechanical pencil, say 0.5mm, which produces a constant line without needing to be sharpened.

Eraser

A vital part of your kit. There's absolutely no shame in erasing mistakes and rough guidelines; they are an important part of the drawing process. There are dozens of varieties on the market, but they all do essentially the same job.

Paper

A cheap A4 sketchpad would be good to get you started, but virtually any paper will do fine. I did most of the drawings for this book on scrap photocopier paper. For the beginner, expensive paper only inhibits your freedom to make mistakes.

HANDY HINT
Buy pencils of different grades with different coloured shafts so that you can identify them at a glance.

MORE ADVANCED MATERIALS

As you progress though the book, you'll come across other tools and materials you might want to experiment with. Here are a few inexpensive items you could add to your kit for giving your drawings a professional finish.

Drawing pen

Felt-tip drawing pens are very easy to use and come in a range of thicknesses from as fine as 0.1mm. A couple of grades, say 0.3mm and 1mm, should be all you need for most inking jobs.

Dip pen

These are the traditional manga tools, dipped into ink to produce lines of varying thickness. But they are difficult to use and can be very messy.

Black ink

A bottle of black drawing ink is very useful and will last for a long time. Used neat, it is excellent for dense lines and solid shadows or it can be watered down for any shade of grey.

Brush pen

A bit more tricky to handle, brush pens are very versatile felt-tips that are great for producing authentic manga style line work. As well as the standard black, they come in various shades and colours that can be used for more delicate shading and rendering.

Brush

One good quality round watercolour brush will do for most jobs, whether inking fine lines or filling in larger areas of solid black ink. Number 3 or 4 is a versatile size, as long as it has a fine point. Always wash brushes carefully and reshape the point immediately after use.

White ink

White drawing ink applied with a brush is great for correcting mistakes and for adding bright highlights to give your artwork that extra sparkle. Make sure you shake or stir the bottle well.

HANDY HINT

For using a dip pen or if you expect to use a lot of ink on a drawing, it's a good idea to use heavier grade art paper, which won't buckle with the moisture.

A HEAD START

The face carries most of the personality and expression of a manga character, so it's an excellent subject to begin our study. But before you can think about manga characters, you'll need to know about how the parts of the face and head fit together.

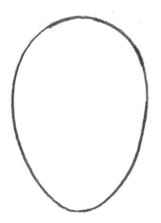

Step 1
It all begins with an upside-down egg shape. I've drawn it dark so you can see it clearly, but you should draw yours very faint, with a hard pencil (H or HB). And don't make it too small.

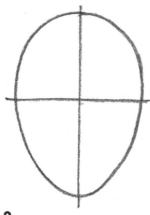

Step 2
Mark straight lines exactly halfway down and across.

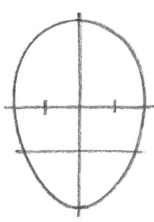

Step 3
Now divide those lines in half again: a long line across the bottom half and short dashes on either side of the vertical.

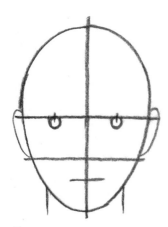

Step 4
From the guidelines you've drawn, it should be easy to start placing the features. The eyes sit just below the middle line, the ears start and finish just above the horizontal lines. Add lines for the mouth and neck.

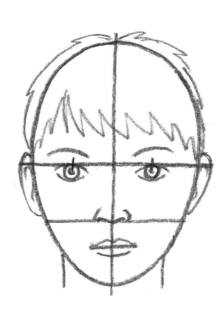

Step 5
Now it's just a case of drawing in the features. With everything in place, this looks like a teenage boy, but with different hair it could just as easily be a girl.

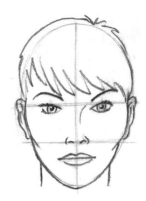
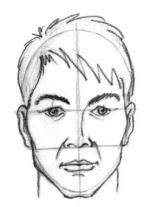

Just by changing the features and the jaw lines, the same guidelines can be used to draw a fairly realistic man or woman.

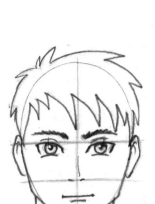
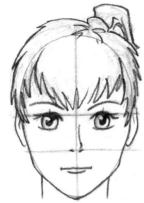

And with different changes to the features, we can turn our guidelines into manga characters.

Making the eyes larger and shortening the chins, it's easy to draw faces in a younger manga style.

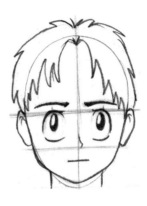
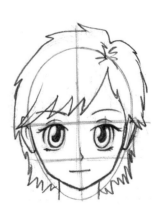

Already we can see that the level of the eyes within the head indicates a character's age. This chart compares the proportions of typical manga faces at different stages of life.

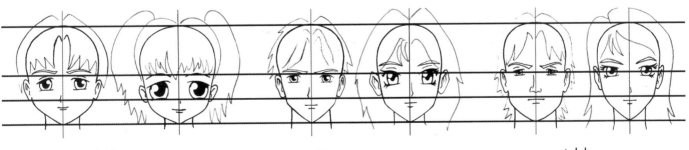

Children Teenagers Adults

MANGA FEATURES

Manga characters may be old or young, good or bad, good-looking or plain and their faces may vary greatly in proportions and features, but there are certain distinctive hallmarks that help to define manga from other comic book styles. Here are some of the common characteristics.

Hair is usually quite sculptural with strongly defined tresses and shiny highlights. On female characters it may be very long indeed.

Eyes are large with bright highlights. Female eyes tend to be larger and more ornate. Male eyebrows are usually heavier.

Noses are very simply drawn and turn up at the end.

Mouths are small and simple, but become more defined when displaying extreme emotion.

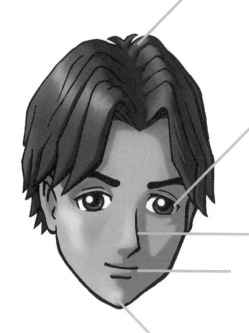

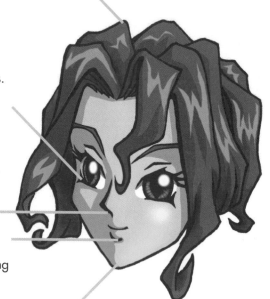

Jaw lines are triangular in shape and often feature quite pointed chins.

MANGA EYES

By far the most distinctive features of a typical manga character are the eyes. Learning to draw eyes is essential to mastering the manga style, so here's a breakdown of the stages involved in drawing a typical eye.

Step 1
Start by thinking of the whole eyeball, so draw a circle and then add lines for the shape of the eyelids.

Step 2
Next comes the pupil (the central black part) and iris (the coloured part), parts of which are usually covered by the upper eyelid.

 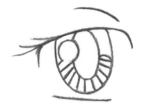 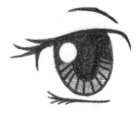

Step 3

Now draw a circle for the bright highlight. You could also mark where the eyelid shades the iris.

Step 4

Radiating lines are often a nice detail in the iris. Make sure they all go to the same point in the centre of the pupil. Add some guidelines for the eyelashes.

Step 5

Now go over your guidelines with darker pencil. Make sure you indicate the upper outline of the eyelid before erasing your unwanted guidelines.

Step 6

Fill in with solid black and strengthen the eyelashes. To finish, lightly shade the iris and then tidy up around the edges with an eraser.

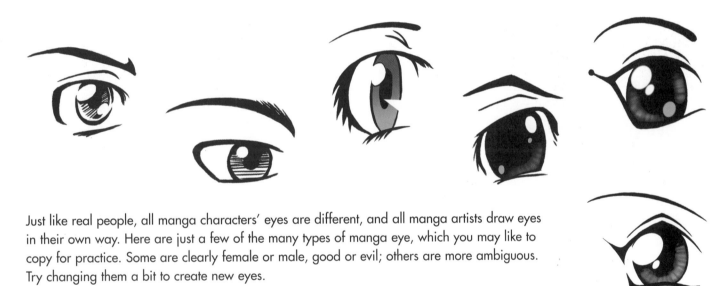

Just like real people, all manga characters' eyes are different, and all manga artists draw eyes in their own way. Here are just a few of the many types of manga eye, which you may like to copy for practice. Some are clearly female or male, good or evil; others are more ambiguous. Try changing them a bit to create new eyes.

13

HEADS FROM DIFFERENT ANGLES

As people move around, we see their heads from all different angles. If you can draw your manga characters from different angles you will be able to show them in various activities, emotions and interactions. It can seem quite complicated, but once again some rough guidelines will make the process much easier.

3/4 VIEW

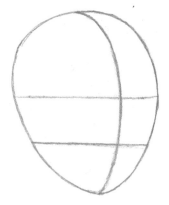 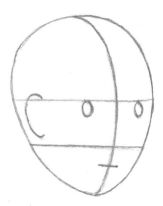 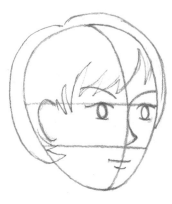 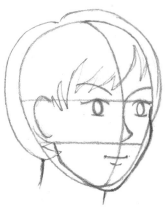

Step 1
To draw a three-quarter view (where the head is turned to one side), start with the egg shape, but make it broader towards the top and back. Place your horizontal guides as before. The essential difference here is that the vertical guideline must sit to one side of centre and curve.

Step 2
Positioning the eyes, ears and mouth should now be quite easy.

Step 3
Now the rest of the features can be drawn in position.

Step 4
For manga, it's important to define the outline of the cheek and jaw. The line comes in at the eye socket, out to form a cheekbone, then down to the characteristic triangular chin. Note how the neck slopes forward.

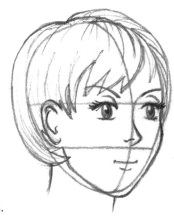 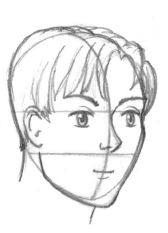

Step 5
Then it's just a case of refining the features and adding the detail, before erasing unwanted guidelines.

This male character was drawn from the same guidelines. The main differences to note are his fuller jaw line and broader neck.

PROFILE

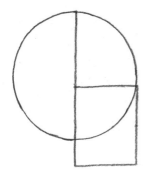 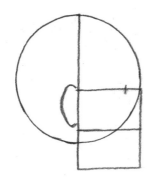 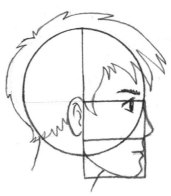 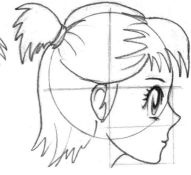

Step 1
Viewed from the side, the head is much wider than when seen from the front. To get used to the dimensions, try to think of the profile as a circle for the curve of the skull and a rectangle for the lower face and jaw. The central horizontal is halfway down the entire head.

Step 2
The ear sits behind the centre vertical and the eye should be placed right near the front of the face.

Step 3
The nose sticks out from the front and the mouth and jaw will fit neatly into the lower box. From this angle, the eye forms a triangle shape and the iris is reduced to a flattened disc.

This female character follows the same framework, but the line of her chin slopes back.

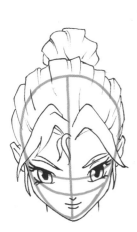 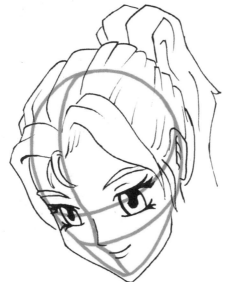 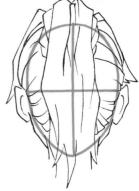 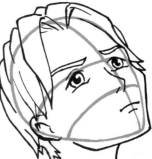

Once you get used to the proportions of profiles, you'll probably find it easier to start from a broadened egg shape. Using the egg shape, you should be able to draw the head from any angle, as long as you put the guidelines in the right places. Study these diagrams and note how the guidelines follow the curve of the head, up, down and from side to side.

CHARACTER AND EXPRESSION – MALE

There's much to be learned from copying characters from books, but the real fun begins when you can create new characters and bring them to life with expressions and interesting angles of view. Here are just a few examples of characters drawn from my imagination, showing a range of personalities and emotions. To begin designing characters of your own you could use these examples as starting points.

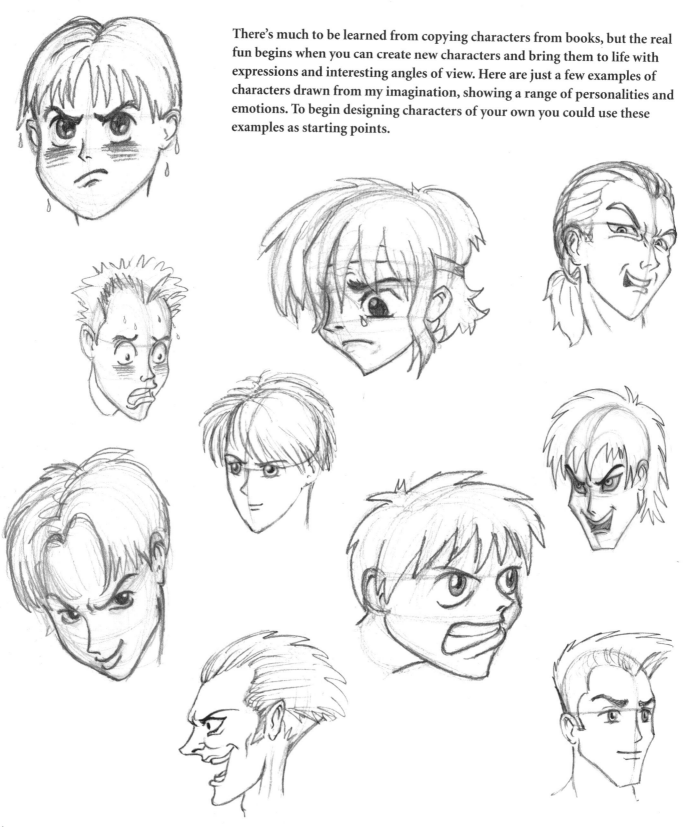

CHARACTER DESIGN 1

Taking elements from the examples shown, here's a simple method for creating a new character.

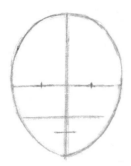

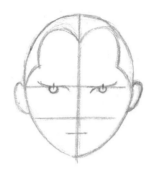

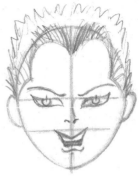

Step 1

A front view is perhaps the easiest start for a new character. I decided on a young face, so started with quite a squat egg-shape.

Step 2

Next I added more details to my guidelines.

Step 3

Copying features on to the guidelines, a character very quickly started to emerge.

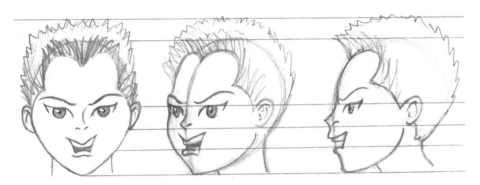

Step 4

Refining the features and face shape, I completed the front view. But this is only a first stage in the design. Drawing the nasty little fellow from other angles will help me to see how he works three-dimensionally. Ruling some horizontal lines from the main features is a great way to keep a face's proportions consistent.

Here's a really easy way to try out variations on a character. A three-quarter view works best because it allows you to draw the front and side at the same time. Place a piece of tracing paper over the original drawing and, as you trace it, make slight alterations. To see how my character works as a good guy, I enlarged the eyes, made the eyebrows and mouth less spiteful and gave him a gentler hairstyle.

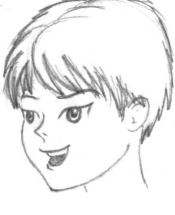

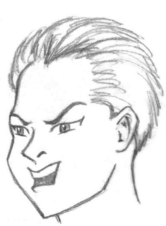

To draw him as an older character, I moved the tracing paper around to make his face longer and generally tweaked the features to suit. Using tracing paper, you can go on making endless adjustments until you are happy with a final design.

17

CHARACTER AND EXPRESSION
– FEMALE

If you compare these examples of female faces with the male ones, you'll notice that the girls' expressions tend to be less dramatic than the boys. But what the girls lack in expression, they make up for in variety, tending to be more diverse in hairstyles, eyes and, as we'll see later, costume.

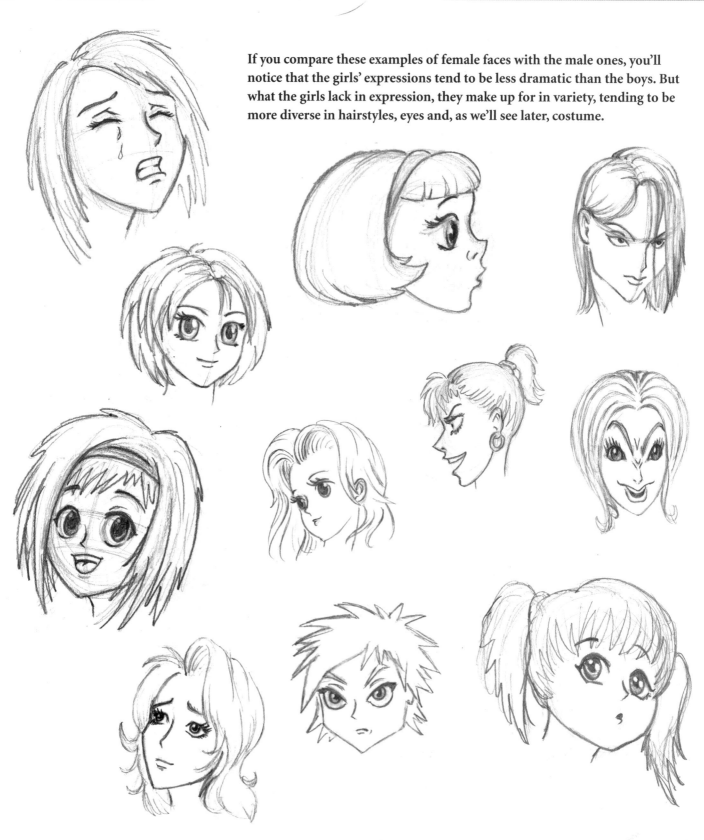

CHARACTER DESIGN 2

To design a new character based on elements of these examples, the process is just the same as for a male character. Start with the appropriate egg shape and mark the guidelines, then gradually build up the details until a new face is looking back at you.

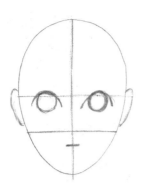

Step 1

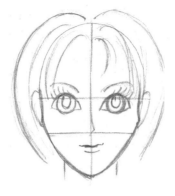

Step 2

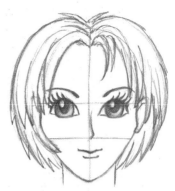

Step 3

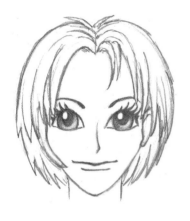

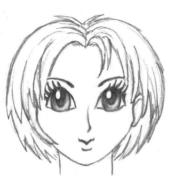

As well as developing characters as younger or older, good or bad, try versions with features at different sizes or positions. Tracing paper will help you to make lots of new drawings without having to start from scratch every time.

On the left I've redrawn the character with longer and shorter face shapes and altered the sizes and positions of the mouth, eyes and eyebrows. You can see how they look quite different even though the features are exactly the same.

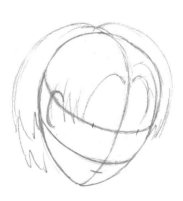

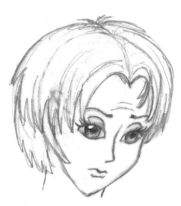

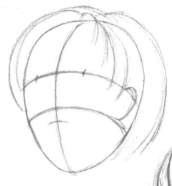

Try drawing a new character from different angles and with different emotions. In the examples above I used the tilt of the head to reinforce the expressions. Note how in each case the vertical and horizontal guidelines curve around the egg shape.

19

INKING

The chances are that by now you'll have some drawings you're pretty happy with. So to move things on to the next level we'll look at how you might progress towards making your work clean, polished and professional. The most important aspect of manga presentation is inking.

All the important elements of a drawing are in the pencil work. But with scruffy marks and guidelines, a drawing like this does not look very slick.

With a sharp, soft pencil and very careful erasing you can achieve quite neat line work. For very fiddly work, I use an eraser that comes in pencil form and can be sharpened to a point. But still there are rough marks that can't be got at, and overall that outline is quite grey and pale.

If you draw the final outlines in ink, all the rough pencil marks can be erased in broad, swift strokes and you're left with a clean picture of strong dark lines. This is the most basic form of inking, using a cheap fine-tipped felt-tip pen. Such pens produce lines of even thickness.

HANDY HINT

A bottle of white drawing ink and a fine pointed brush are very useful for correcting mistakes. Always shake the bottle well before use and wash the brush thoroughly afterwards.

Dip pen
Many manga artists use old-fashioned dip pens, with steel nibs that you dip into ink. Because the nibs are flexible, the line they produce is varied in width, depending on how hard you press. The results can be fabulous, but you need lots of practice and it's very easy to make a mess.

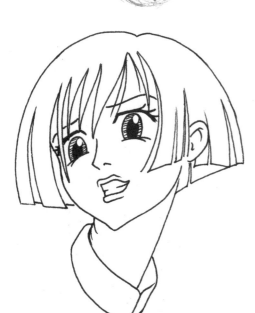

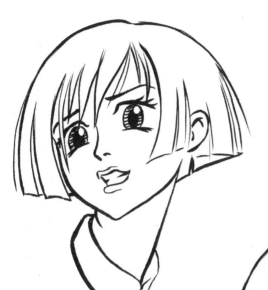

Brush pen

Much easier to use are brush pens, which are felt-tips with a nib like a Chinese brush. Their varied line gives a very authentic manga finish. The same look can be achieved with a fine watercolour brush and ink.

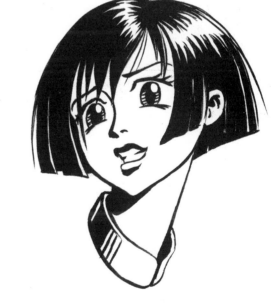

You can take the inking a stage further and use solid black details to convey a sense of light and shade. Be careful not to overdo it though; try to maintain a good balance of white.

HANDY HINT

Move your paper around as you go so that your inking hand can follow its natural arc for every line it draws.

To ink the hair, be careful to leave some white for the shine. It's a good idea to draw the highlighted areas first in pencil. Any large areas of solid black should be filled in with brush and ink for a smooth, unbroken finish.

21

LIGHT AND SHADE

As light falls on objects it illuminates some parts and casts others into shade. In capturing the interplay of light and dark, or 'tone', you create the illusion of three-dimensionality on the flat surface of the paper. Using tone in your drawings helps to bring your characters to life.

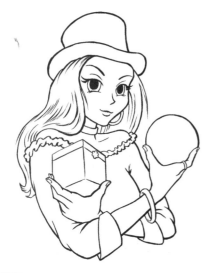

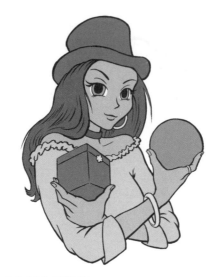

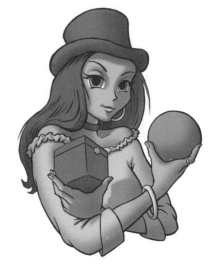

LINE
In this line drawing, there is very little evidence of light and shade. We do get some sense of three-dimensionality because some parts overlap others, but generally the picture looks quite flat.

LOCAL TONE
In this version, I've added the 'local tones' – the basic tonal values of the various parts of the picture – pale skin, darker hair and so on. This gives us more information about the character, but it's still a very flat picture.

SHADE AND SHADOWS
Here the parts facing away from the light have been shaded, giving the picture some depth and solidity. We can tell that the light is coming from quite high on the left. Note that some parts affect others, like the box casting a shadow across the chest.

HIGHLIGHTS
Adding 'highlights' gives another dimension to the shading and a sense of shine. The shinier the surface, the brighter and sharper the highlights will be. The weaker highlights around the darker edges result from the 'reflected light' that bounces off surrounding surfaces.

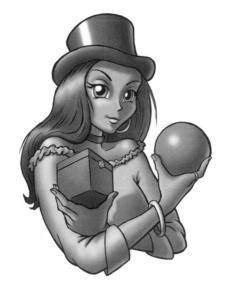

For shading, all forms can be thought of as variations on the three basic forms included in this picture: the box, the ball and the cylinder (of the hat). They each reflect the light differently. The box has sharp shifts of tone between its faces, the ball has curved shading and round highlights and the cylinder is shaded and highlighted in strips along its length.

LIGHTING DIRECTION

When adding tone to your drawings, it's important to make a firm decision about the direction of light and keep it consistent. Think about which parts receive the full glare of the light, which parts are in deep shadow and also the parts upon which the light glances. I've shaded these drawings in with a soft pencil, starting very lightly and gradually building up the darker areas layer by layer.

Front light

Rather like a flash photograph, here the light hits the face full on and tends to flatten out many of the features.

Top light

With the light from above, the features are once again bleached out, but there is a more dramatic feel to the drawing.

Under light

When a face is lit from below, it can be quite eye-catching and often very spooky looking.

Side light

Lit directly from the right, this face seems more solid and characterful.

HANDY HINT

Remember that highlights in manga eyes will move according to the direction of the light source.

23

RENDERING

There are lots different materials and techniques that can be used for shading, or 'rendering' your drawings. Each has their strengths and limitations and the results can be quite distinctive. Here are some of the techniques that are most appropriate for manga.

Ink hatching

For ink shading, use a fine felt-tip pen to draw the shading in thin, even strokes. Where deeper shade is required, go over the drawing again, but change the angle of your lines. This way you can build up quite subtle tones.

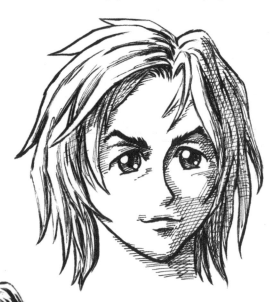

Pencil

You should be quite confident with pencils by now, so perhaps that's the best way to start your rendering practice. Use a soft pencil and don't be too timid; you can always erase mistakes.

Solid black

This is a more extreme version of the tonal inking we saw on page 21. Using ink and a brush, you have to clearly decide which areas are in light and which are in shade; there are no shades of grey in between. In some ways it is a little crude, but it can be effective for night scenes.

Felt-tips

Surprisingly professional results can be produced with simple cheap felt-tip pens (below). The secret is simplicity; restrict yourself to one or two shades and try to lay them on as cleanly as possible, without the pen strokes showing. Don't try to be too subtle or ambitious or you could end up with a mess.

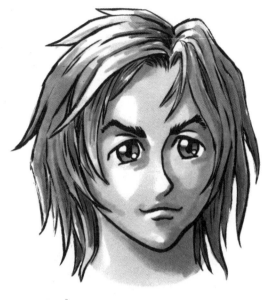

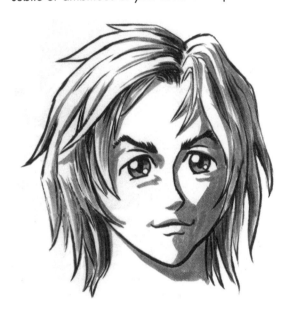

Markers

Professional quality felt-tips can produce very soft and subtle shading (above). They are very expensive, but for black and white work, you only need a couple of shades because you can use them to build up tone in layers. Try to leave some of the white paper showing for the brighter highlights. (See page 43 for more details.)

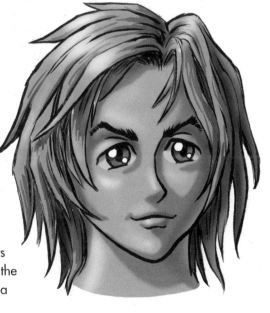

Digital

Nowadays, a lot of manga artwork is scanned into computers and rendered using sophisticated software. The results can be very slick, but remember the computer is only a tool; it needs a competent artist to control it.

HANDY HINT

If you photocopy your ink line drawings you can use the copies to experiment freely with different renderings without fear of ruining your original drawing.

THE BODY

The human body is a very complex machine, capable of powerful and dynamic movements. It can also be graceful in pose and subtle in body language. In manga, bodies are often exaggerated in their proportions and actions, but they are always informed by the workings of real human bodies.

In drawing manga heads, you will have learned a lot about proportion, character, inking and rendering; you'll need all these skills and more as you take on the challenge of the manga figure.

THE BARE BONES

The skeleton provides a kind of internal scaffolding that supports our bodies in all our physical activities. It is also what artists use as the starting point for designing and drawing manga figures in all their dramatic action. A basic working knowledge of the skeleton is essential for successful manga figure drawing.

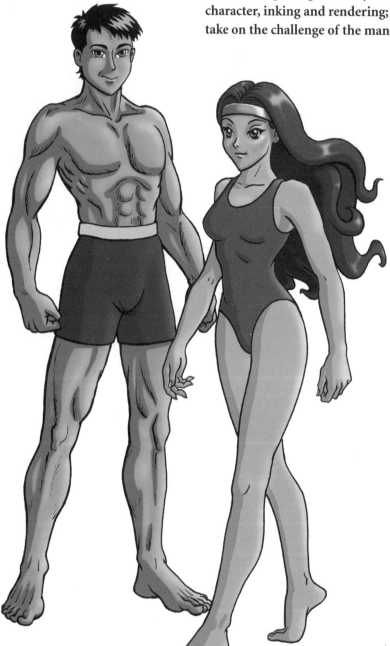

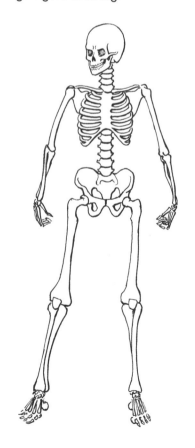

Made up of dozens of bones, the human skeleton is a confusion of sticks and knobbles. But just as we simplified the skull to a basic egg shape, so the skeleton can be reduced to its main parts. This is the basic framework that artists employ. It contains all the necessary information: the proportions of the head, chest, hips and limbs and the positions of the joints. Hands and feet are treated as general masses.

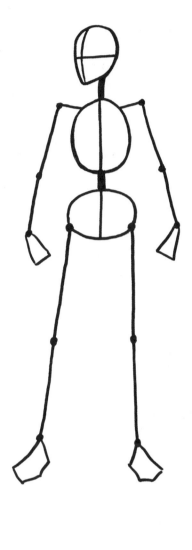

Turned to a 3/4 view, we can see the curve of the chest and hips that will help with drawing the full body. This is the basic skeleton that the picture opposite started out as.

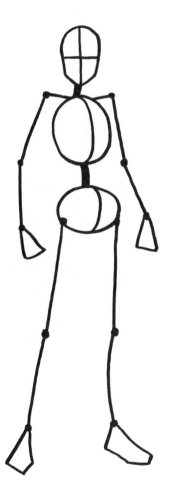

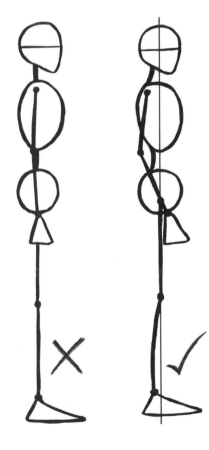

From these profile views we can see the difference between well and badly drawn posture. From just the few lines of this skeleton, it is noticeable that one pose is strangely stiff and the other is more natural and relaxed. It's all too easy to make figure drawings too rigid, but starting from a well-posed skeleton will help to make a convincing final drawing.

PROPORTION

Although heights and builds vary enormously, it's possible to establish some general guidelines about realistically proportioned figures. Artists often think of the body in terms of head heights because whatever the size of a head, the rest of the body is generally in proportion with it.

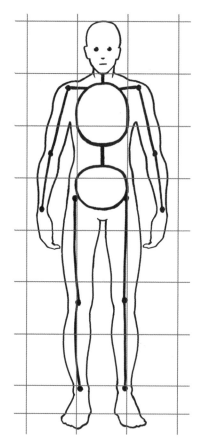

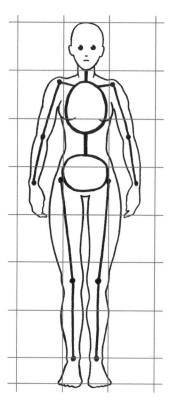

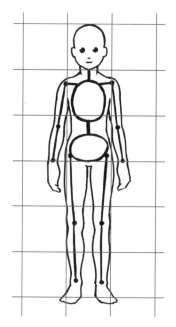

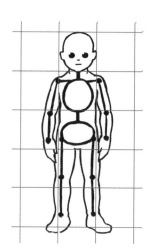

Man

This adult male follows the average proportions of about seven and a half heads in height. Divisions can be imagined at the level of nipples, navel and so on, and the wrists and crotch fall at about half the overall height. The width at the shoulders is about two head heights.

Woman

A female adult, though generally shorter, follows the same vertical proportions relative to her head size. Her build will generally be less broad than a man's though relatively fuller at the hips. These diagrams are only a rough guide; proportions from six and a half to eight heads are not uncommon in real people.

Child

The head of an eight-year-old child is larger in proportion to its body, being about six heads tall. The wrists and crotch still fall at about half the overall height.

Toddler

A toddler's head is about a fifth of its overall height. The head at this age is distinctly more squat in shape than an adult's and its legs are shorter relative to its body. By the age of two, a child is already half adult height.

MANGA PROPORTIONS

A lot of manga characters follow the natural proportions of real people, but others can be quite wildly exaggerated in height, build and musculature.

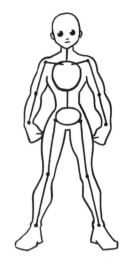

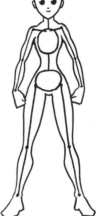

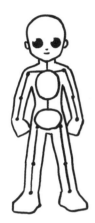

Even tiny kids can become manga heroes with narrowed torso and sturdy limbs.

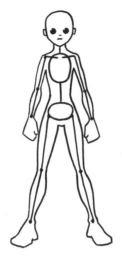

Child and teenage bodies may be streamlined and drawn with defined muscles. They may even be given adult qualities, such as curvy figures for girls or bulky muscles for boys.

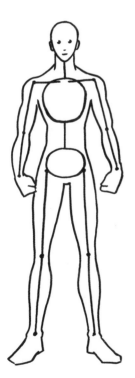

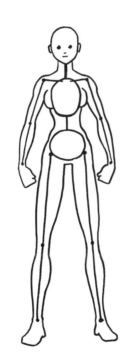

The muscular bulk of superhero or villain characters may be expanded far beyond the build of any real person.

It is very common for manga artists to elongate figures to eight or nine head heights. The longer limbs make them graceful, like fashion models.

DRAWING THE FIGURE

Here I have illustrated the stages you might go through to draw a finished manga figure. I've chosen a fairly simple, static karate pose in which all the body parts are clearly visible. For your first attempts at figure drawing you might find it helpful to copy a pose from a photograph.

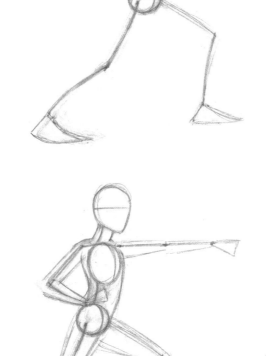

Step 1
Having decided to draw a teenage boy, I lightly sketched the skull, ribs and pelvis, giving each the appropriate manga dimensions and spaces in between. Make sure you leave enough space on the paper that you don't restrict the limbs.

Step 2
In drawing the shoulders, arms and legs, I had to use my eraser quite a lot as I adjusted their positions and proportions. It is vital that you are happy with the skeleton before you go any further.

Step 3
I started fleshing out the figure by sketching in the broad masses. Think about which parts are more heavily muscled and where the bone is closer to the surface, such as the calves and shins. Note that the flesh is generally less heavy around the joints.

Step 4
Then I refined the contours and musculature. It takes some experience to do this easily, so you may need to consult photographs and look at your own body to build up your knowledge.

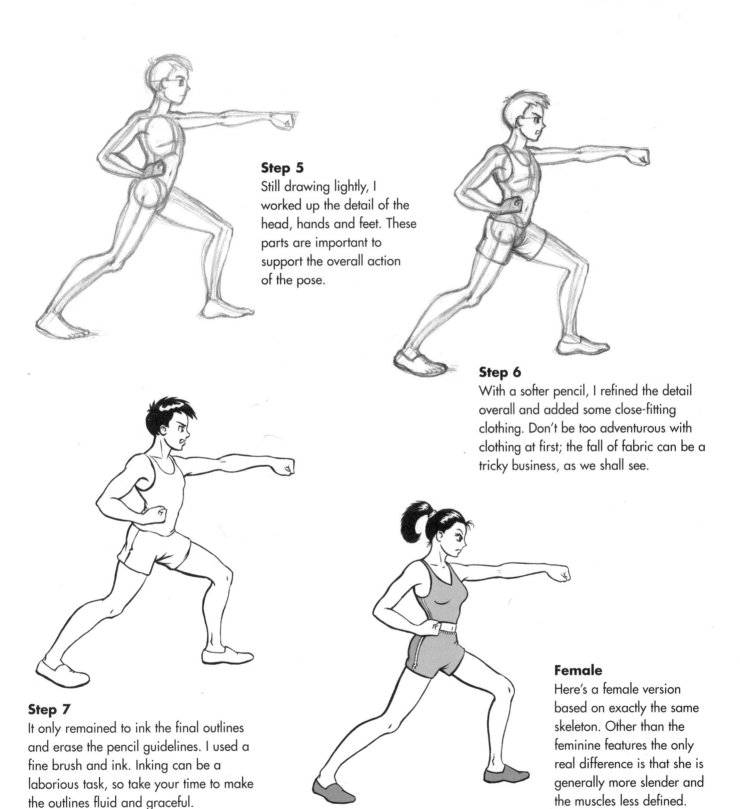

Step 5

Still drawing lightly, I worked up the detail of the head, hands and feet. These parts are important to support the overall action of the pose.

Step 6

With a softer pencil, I refined the detail overall and added some close-fitting clothing. Don't be too adventurous with clothing at first; the fall of fabric can be a tricky business, as we shall see.

Step 7

It only remained to ink the final outlines and erase the pencil guidelines. I used a fine brush and ink. Inking can be a laborious task, so take your time to make the outlines fluid and graceful.

Female

Here's a female version based on exactly the same skeleton. Other than the feminine features the only real difference is that she is generally more slender and the muscles less defined.

31

DYNAMISM AND MOTION

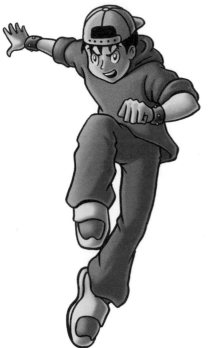

Manga artists waste no opportunity for bringing action and drama to their figures, utilizing a range of comic book devices. Here are some of the basic conventions for drawing the manga figure with dynamic impact.

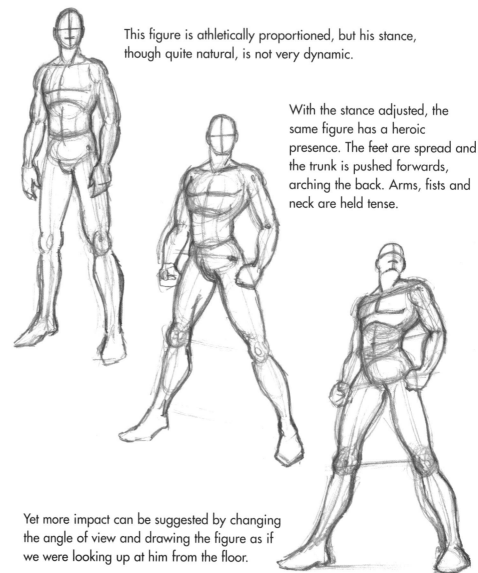

This figure is athletically proportioned, but his stance, though quite natural, is not very dynamic.

With the stance adjusted, the same figure has a heroic presence. The feet are spread and the trunk is pushed forwards, arching the back. Arms, fists and neck are held tense.

A figure in motion is rarely upright and the faster it moves, the more it leans. The animation sequence below shows that the trunk is almost horizontal when running at speed. At the peak of the bound, an unbroken line may be drawn through the figure from the head down to the trailing leg. This is known as the 'action line'. Manga artists pose their dynamic figures around such lines.

Yet more impact can be suggested by changing the angle of view and drawing the figure as if we were looking up at him from the floor.

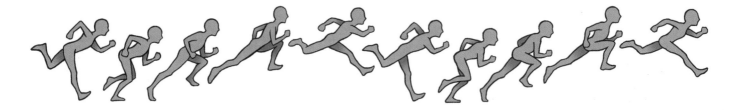

32

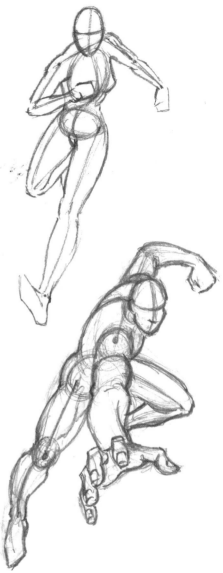

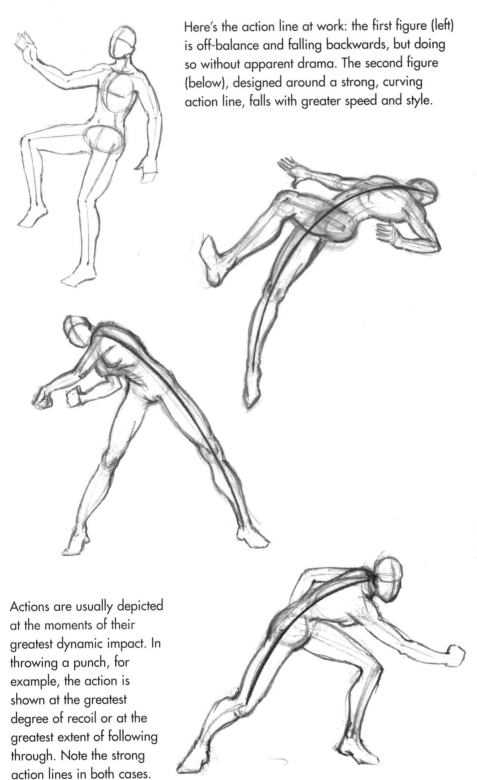

Here's the action line at work: the first figure (left) is off-balance and falling backwards, but doing so without apparent drama. The second figure (below), designed around a strong, curving action line, falls with greater speed and style.

Actions are usually depicted at the moments of their greatest dynamic impact. In throwing a punch, for example, the action is shown at the greatest degree of recoil or at the greatest extent of following through. Note the strong action lines in both cases.

Figures will have impact if they are shown moving towards the viewer. And yet more impact will result if you place the viewer up close to the action. The running figure at the top of the page appears to be at some distance, whereas the figure directly above seems almost to leap out of the page. It is the exaggerated proportion of his hand that makes him seem so close.

A HEROIC FIGURE

In the process of this drawing, we'll cover some of the factors you'll need to convey heroic qualities in your characters.

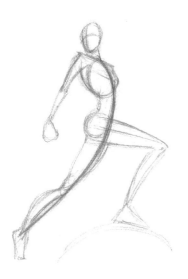

Step 1

The first element to go down on paper was the action line, giving the picture a dynamic thrust from the outset. Then I drew in the rough skeletal shape for a very tall figure. The arched back and turned head lend the pose immediate grandeur.

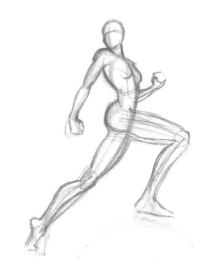

Step 2

In adding the flesh and bulk of the character, I keep in mind that I want it to be lean and athletic. Already I started to develop the musculature.

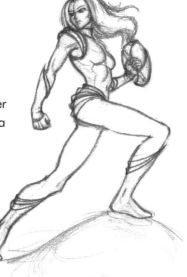

Step 3

Once happy with the general body shape, I erased unwanted lines and developed the hands and face, giving her a suitably serious expression. Over the blank outline I had fun designing a fantasy hero costume. Repeating a shape or motif makes for a cohesive design. I drew the hair as if billowing in the wind.

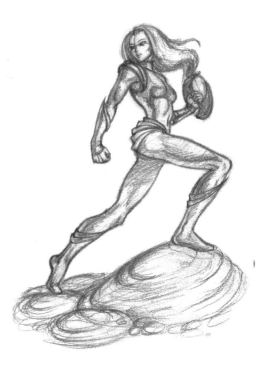

Step 4

Having decided on a light source from above right, I added some pencil shading to guide me for the inking. I worked some form into the alien boulders beneath her feet.

Step 5

Inking artwork requires concentration and a steady hand. I used a steel-nibbed dip pen (see page 20) and regularly turned the paper to make each stroke with a comfortable arc of the hand. Initially, I outlined the figure in bold, fluid lines and inscribed detail in the hair.

HANDY HINT

Ink from a dip pen can take a long time to dry, so be sure that the ink is absolutely dry before erasing the pencil marks.

Step 6

To add shading with ink you have to be quite confident about the form of the surfaces and the fall of light upon them, so thorough pencil work pays off. Look at comics to see how different artists have come up with ways of using solid black and hatching to give their drawings solidity and depth.

Step 7

I scanned my drawing and did the final rendering using Adobe Photoshop. The best way to learn these skills is to experiment with the tools of whatever digital imaging software you have. As long as you keep your original line work on a separate layer, you can endlessly adjust the rendering until you are satisfied.

CLOTHING AND COSTUME

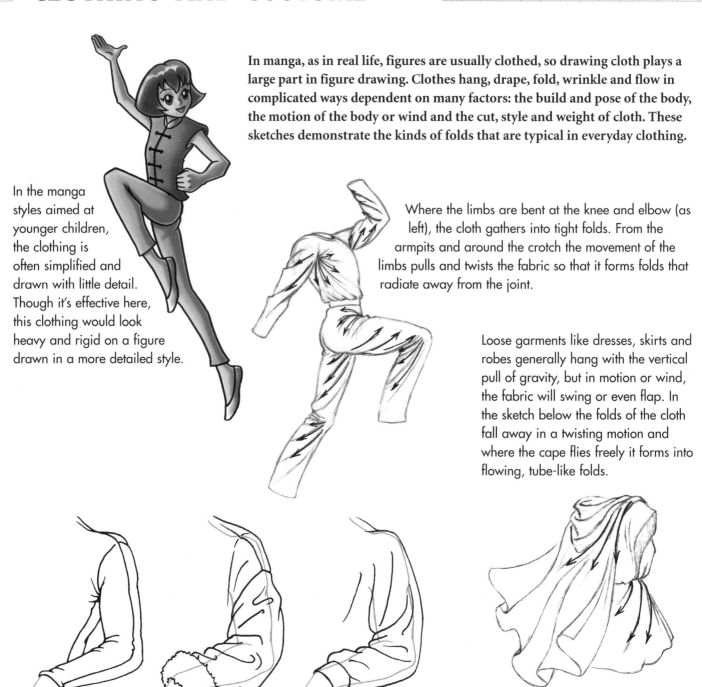

In manga, as in real life, figures are usually clothed, so drawing cloth plays a large part in figure drawing. Clothes hang, drape, fold, wrinkle and flow in complicated ways dependent on many factors: the build and pose of the body, the motion of the body or wind and the cut, style and weight of cloth. These sketches demonstrate the kinds of folds that are typical in everyday clothing.

In the manga styles aimed at younger children, the clothing is often simplified and drawn with little detail. Though it's effective here, this clothing would look heavy and rigid on a figure drawn in a more detailed style.

Where the limbs are bent at the knee and elbow (as left), the cloth gathers into tight folds. From the armpits and around the crotch the movement of the limbs pulls and twists the fabric so that it forms folds that radiate away from the joint.

Loose garments like dresses, skirts and robes generally hang with the vertical pull of gravity, but in motion or wind, the fabric will swing or even flap. In the sketch below the folds of the cloth fall away in a twisting motion and where the cape flies freely it forms into flowing, tube-like folds.

Bear in mind the cut and weight of the cloth if you want your drawings to look convincing. Tight-fitting garments closely follow the body's contours and form small wrinkles inside the bends. Heavier fabric makes bigger folds and large folds can also occur in thin fabric where it is loose-fitting.

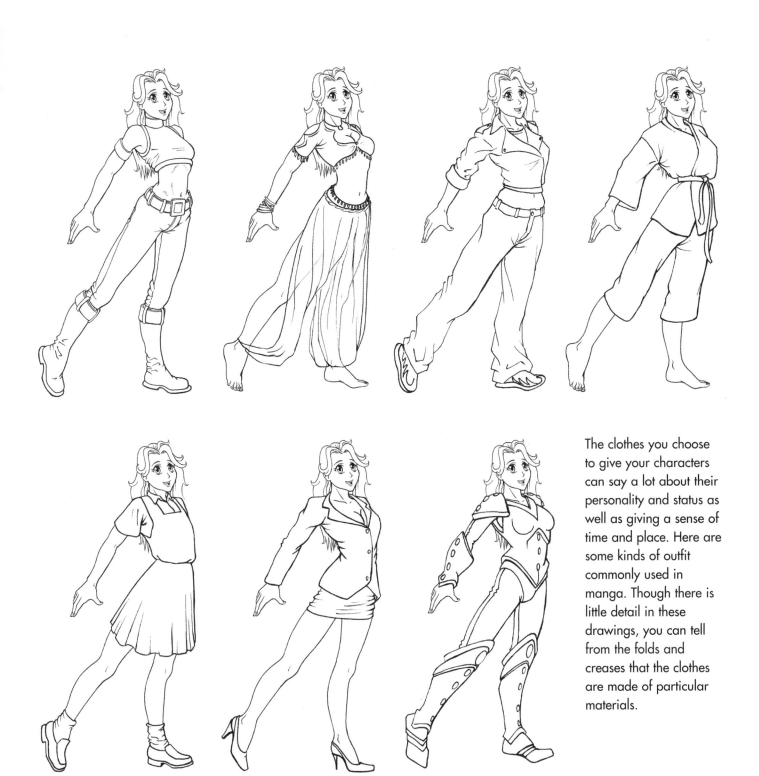

The clothes you choose to give your characters can say a lot about their personality and status as well as giving a sense of time and place. Here are some kinds of outfit commonly used in manga. Though there is little detail in these drawings, you can tell from the folds and creases that the clothes are made of particular materials.

A CLOTHED FIGURE IN MOTION

There's a lot to keep in mind when drawing figures in action: balance, action line, proportions, characterization, folds of fabric and so on. The action can also be reinforced with inking and rendering. All these concepts can be broken down into logical steps.

If you compare this drawing to the similar figure on pages 30–1, you'll see how much more impact these dynamic devices achieve.

Step 1

Here's our standard stick figure, based around a forward-curving action line.

Step 2

Even when you intend to draw a clothed figure, it's important to ensure that the body inside fits together convincingly, so I roughly sketched the main masses of flesh. In doing so, I could see that I needed to change some proportions.

Step 3

Sketching the rough shapes of the clothing, I had to think about the tensions of the action, where the fabric is pulled tight and where it flows and hangs freely. Loose-fitting clothing is not easy to visualize, but marking the directions of movement helps a lot.

Step 4

To avoid confusion, I erased a lot of the underdrawing before working more detail into the clothing.

Step 5

After detailing the extremities, I sketched in some motion lines, tracing the path of the swinging fist. I also marked some straight lines radiating from the fist, which is the focus of the action. These will help with the dynamic inking.

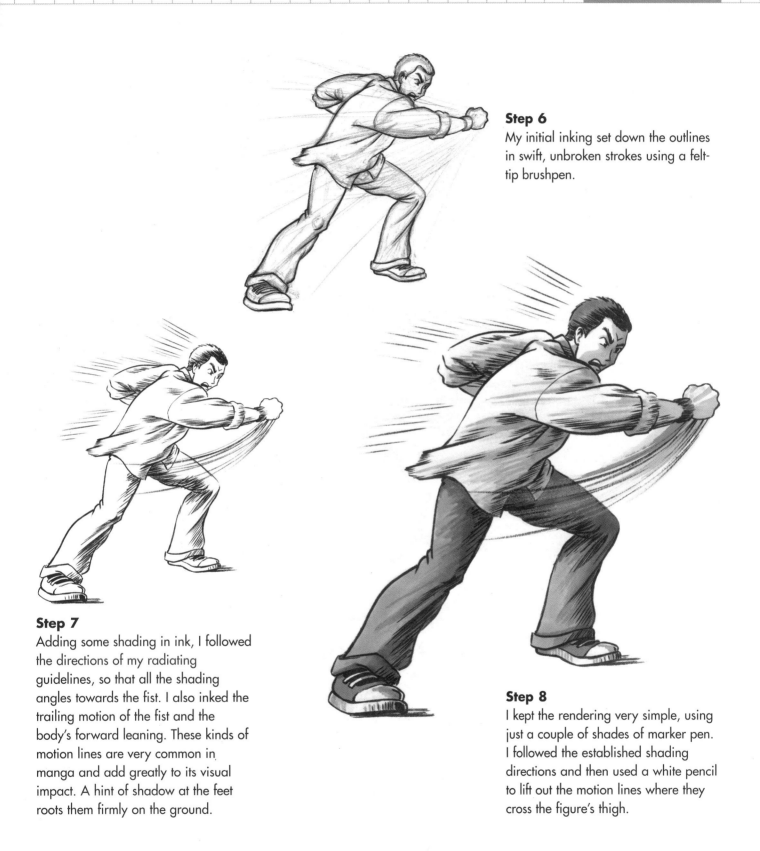

Step 6
My initial inking set down the outlines in swift, unbroken strokes using a felt-tip brushpen.

Step 7
Adding some shading in ink, I followed the directions of my radiating guidelines, so that all the shading angles towards the fist. I also inked the trailing motion of the fist and the body's forward leaning. These kinds of motion lines are very common in manga and add greatly to its visual impact. A hint of shadow at the feet roots them firmly on the ground.

Step 8
I kept the rendering very simple, using just a couple of shades of marker pen. I followed the established shading directions and then used a white pencil to lift out the motion lines where they cross the figure's thigh.

DEVELOPING A CHARACTER

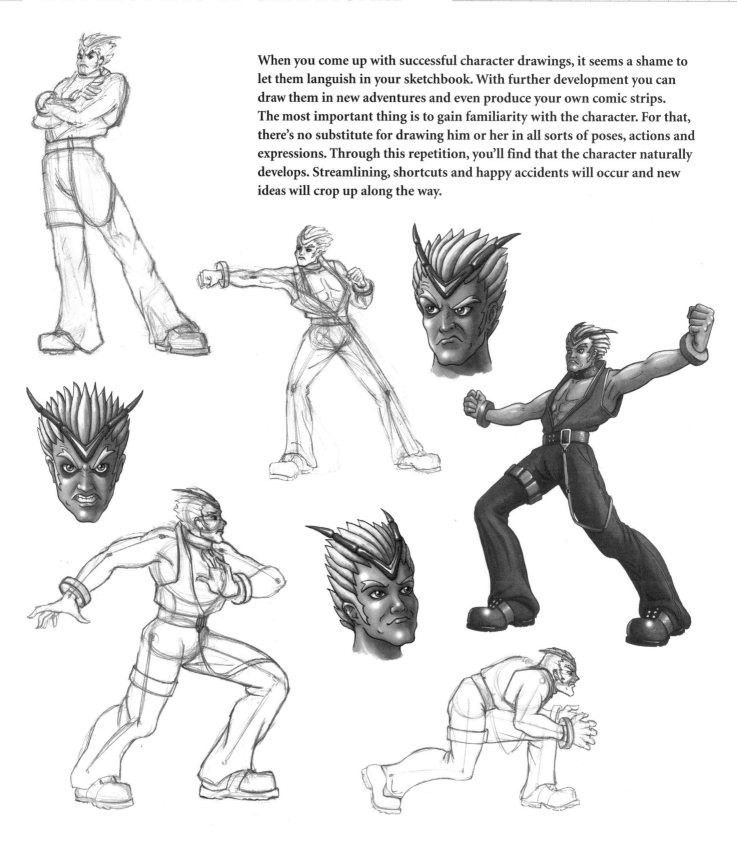

When you come up with successful character drawings, it seems a shame to let them languish in your sketchbook. With further development you can draw them in new adventures and even produce your own comic strips. The most important thing is to gain familiarity with the character. For that, there's no substitute for drawing him or her in all sorts of poses, actions and expressions. Through this repetition, you'll find that the character naturally develops. Streamlining, shortcuts and happy accidents will occur and new ideas will crop up along the way.

DYNAMIC VISUALIZING

To help with the more dynamic aspects of a character, you could try out some different methods of underdrawing. These approaches are useful for visualizing foreshortened body parts, where the skeleton method may lead to confusion.

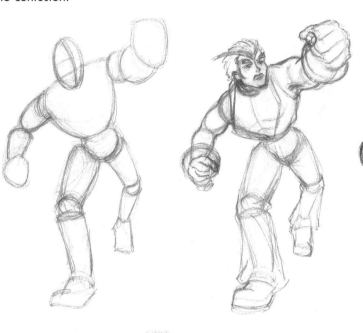

This method treats the body as a series of blocks and cylinders, each with a distinct perspective, facing towards or away from the viewer. This helps to make sense of the exaggerations of scale such a pose demands. You can very quickly build up a convincing figure. Then it's just a case of refining the contours and gradually adding the features, clothing and details. Try to keep the drawing loose and be prepared to change any odd proportions that become apparent along the way.

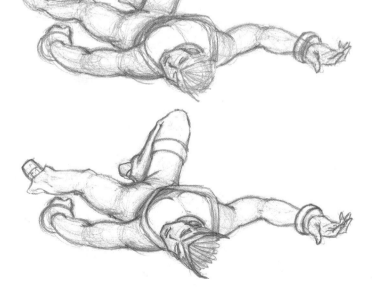

This method is looser still. Lightly scribble in oval movements, barely lifting the pencil from the paper as you search for a suitable form. Draw without detail or measuring, and soon, amongst the mass of lines, you will build up the impression of a body. In refining the drawing, you effectively pick the figure out of the myriad scribbled lines. Once the outlines are established, placing clothing and details should be relatively easy.

MACHINE CHARACTERS

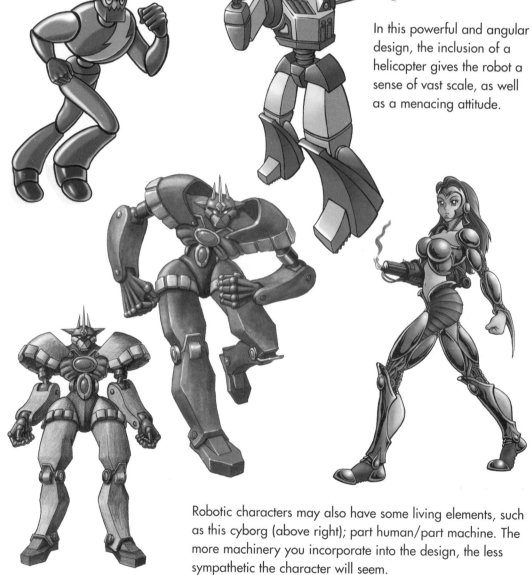

The diverse world of manga is populated by human, superhuman and also inhuman beings. So it's not uncommon to come across mechanical characters. Robots, or 'mechas', are usually in more-or-less human form and in exaggerated proportions, but stylistically they are very varied. When you design your own machine characters, they need only be limited by your imagination.

Above and right is a very simple form of robot, based on old-fashioned children's tin-toy styling. Even though it is very streamlined and basic, it's important to make sure that the design works from all angles and that it has enough articulation for effective movement and action.

In this powerful and angular design, the inclusion of a helicopter gives the robot a sense of vast scale, as well as a menacing attitude.

The machine on the right (shown standing and running) is powerfully constructed and futuristic in design. It is also complex and angular and therefore difficult to replicate in different angles or actions. It can be useful to try out different rendering techniques to see which works best for the design. Here I used pencil and marker pens.

Robotic characters may also have some living elements, such as this cyborg (above right); part human/part machine. The more machinery you incorporate into the design, the less sympathetic the character will seem.

INKING AND RENDERING

The hard, shiny and slick surfaces of robots require particular treatment as you take them to finished artwork. For them to look like sophisticated, precision-built machinery, your inking and rendering should be well-planned and unfussy.

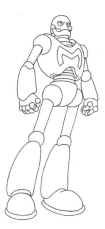

Step 1

To get a clean outline, it's sometimes best to start with the uniform line of a fine felt-tip pen and then erase all pencil guidelines.

Step 2

Here I strengthened the outlines, using a ruler and circle templates where necessary. I thickened the edges on the shaded side so as to give the outline a sense of solidity.

Step 3

A few bits of detailing and some very simple shading lend a different feel to the various surfaces that make up the body.

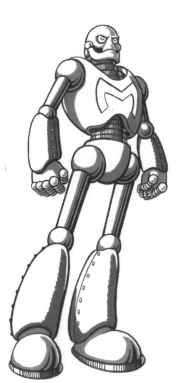

Step 4

For the rendering, I used marker pens, but ordinary felt-tips can produce similar results if used with swift, confident strokes. In pale grey, I filled in the main areas of shadow on the lower right edges.

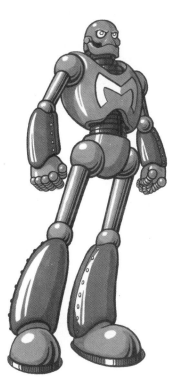

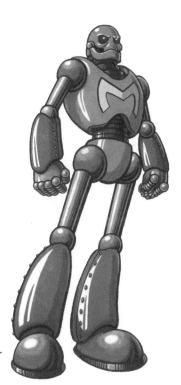

Step 5

Next, I filled in each area in turn, covering the previously shaded parts, but leaving some white paper for highlights. I used a darker pen for the forearms, shins and internal body.

Step 6

For the final touches, I beefed up the shading here and there and added some extra bits of highlight with white ink.

43

DESIGNING A ROBOT

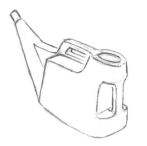

Setting out to design new characters can be quite daunting when you're faced with a blank white page. But much character design begins with a source of inspiration or a theme, and this is especially true of robots. Deciding on a theme leads to a harmonious design – imagine robots based on the styles of racing cars, jet fighters, pinball machines or electronic components. Sticking to a theme can also solve a lot of painful decisions by cutting out many possibilities.

For this exercise, I selected some of the everyday objects in my house. These objects are all quite mundane, but each has some interesting elements to their form. They are all man-made and functional in style.

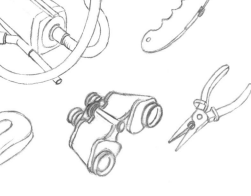

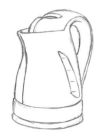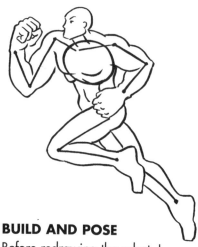

Without any great concern for pose, proportion or characterization, I quickly assembled this sketch from elements of my chosen objects. I started with the basic trunk shape, based loosely on the watering can, and kept adding to it bit by bit. The challenge is then to make a graceful, cohesive design out of all this junk.

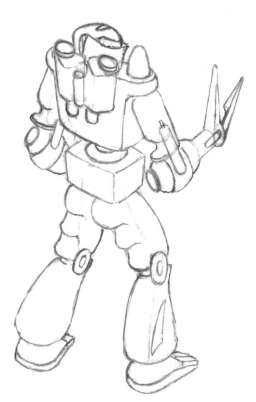

BUILD AND POSE

Before redrawing the robot, I considered his overall build and proportions and a suitable pose. To avoid the design looking too cumbersome, I decided to base the drawing around an athletic human figure in a dynamic pose. If the robot can match this pose, it will look agile.

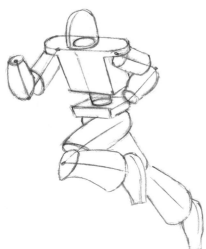

Step 1

I started with the main blocks, making sure that they work in perspective. It's worth taking a lot of care over this stage, to get the foundations right before adding confusing details.

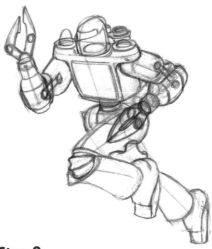

Step 2

Introducing more details and styling, the original household objects get less recognizable. It became clear that the hips were not going to work, so I removed the rectangular block that seemed to restrict the leg movements. Try to keep your designs loose and changeable.

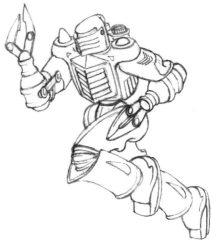

Step 3

With the basic robot in place, I could then clean up the drawing and add some decorative features.

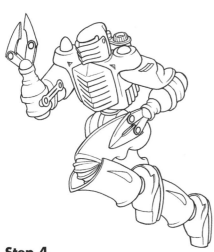

Step 4

To keep this complex design clearly readable, I made the inking quite simple and strove for precise outlines.

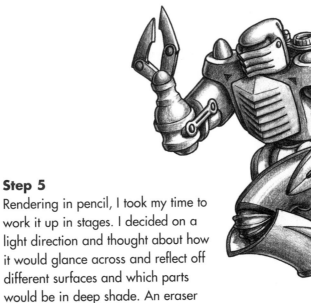

Step 5

Rendering in pencil, I took my time to work it up in stages. I decided on a light direction and thought about how it would glance across and reflect off different surfaces and which parts would be in deep shade. An eraser was useful to lift out some highlights and clean up around the edges.

ANIMAL CHARACTERS

Like human and machine characters, manga animals can vary greatly in their styling and proportions.

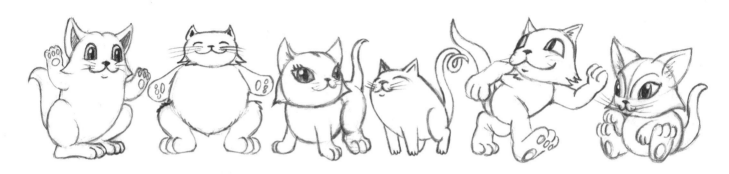

Cute animal characters or mascots commonly feature in manga. They are usually quite small and have large heads in proportion to their bodies, being typically two to three heads in height. Above are just a few manga characterizations of the same animal.

Larger animals may be made cute too, by enlarging the eyes and softening the features.

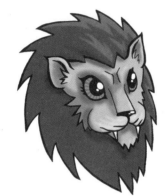

Other manga artists prefer to draw animals more naturalistically and retain a creature's natural dignity.

Another take on the lion comes from mythology, where the lion is the basis for dragon-like characters.

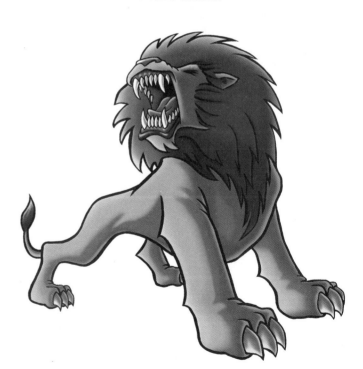

An animal's attributes can be greatly exaggerated for dramatic effect. This lion's proportions (above) are designed for maximum strength and fierceness.

HUMAN HYBRIDS

Manga animals may be given human qualities, humans may have animal features and other characters may be an equal blend of species. Designing hybrids you can be as subtle or imaginative as you like.

The character on the left is basically human but for the styling of her head. I based the features of this alien character on those of a sheep.

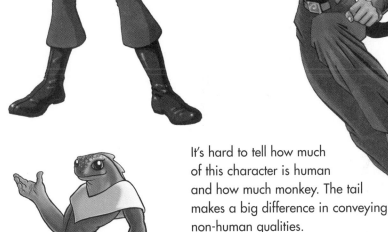

It's hard to tell how much of this character is human and how much monkey. The tail makes a big difference in conveying non-human qualities.

These creatures are very much animal in their features (wolf and salamander respectively), yet they have distinctly human proportions, gestures and posture. It is clear that one is kindly and the other evil, but they could easily be redesigned for different personalities.

And then there are those manga characters that belong to no discernible species at all.

INDEX